D1200716

INCARCERATED:

VISIONS OF CALIFORNIA IN THE 21ST CENTURY

Paintings and Prints from the PRISONATION Series
by Sandow Birk

LAST GASP

© 2002 Sandow Birk
Copyright for the illustration "Ecology of Fear" is owned by Dreamline
Graphics.

Copyright for the illustration of Joseph Wright of Derby's painting
Joseph Arkwright's Mill, View of Cromford, near Matlock, 1783, is
unknown.

Santa Barbara Contemporary Arts Forum
653 Paseo Nuevo, Santa Barbara, CA 93101
805.966.5373
sbcaf@sbcaf.org
www.sbcaf.org

LAST GASP
777 Florida Street
San Francisco, CA 94110
415.824.6636
www.lastgasp.com

ISBN# 0-86719-534-7

The first printing was published by the Santa Barbara Contemporary
Arts Forum and LAST GASP in conjunction with the exhibition INCAR-
CERATED: VISIONS OF CALIFORNIA IN THE 21ST CENTURY Paintings
and Prints from the PRISONATION Series by Sandow Birk July 7–August
19, 2001. This catalog is made possible by a generous gift from Basil
Alkazzi.

The 2nd printing was published by Last Gasp of San Francisco.
Ronald E. Turner publisher in conjunction with the gallery exhibitions
at 111 Minna St. gallery and the Catharine Clark gallery, both in San
Francisco.

Catalog Design:	Ginny Brush, Brush & Associates
Typefaces:	Impact and Frutiger
Scanning:	Armstrong Imaging Center
Printing	Prolong Press Hong Kong
1st Edition:	2,000 copies
2nd Edition:	3,000 copies

Sandow Birks work can be seen beginning June 20 at the Minna
Street Gallery also at Catharine Clark gallery beginning July 28, 2002.

Table of Contents

Lenders to the Exhibition

Mark Andrus

Sandow Birk

Catharine Clark Gallery

Nick Debs, Debs & Co.

Kay and Jon Gosse

Angela and Gerry Harrington

Kevin King

Koplin Gallery

Greg and Marcela Phillips

Marcia Tanner and Winsor Soule

Mark Sinykin and Kevin Osinski

Mr. and Mrs. Edward Byron Smith, Jr.

Exhibition Sponsors

Basil Alkazzi

Catharine Clark Gallery

Koplin Gallery

Fred Page, Page Appraisers

Ron Turner, LAST GASP

Foreword

Meg Linton, *Curator of the Exhibition and Executive Director, Santa Barbara Contemporary Arts Forum*

When Sandow Birk first presented his idea of visiting every state penitentiary in California and painting these ominous facilities in a style similar to Thomas Cole, Frederic Remington, Frederick Church, Thomas Moran, and Albert Bierdstadt, I was fascinated.

He spoke of the failure of Manifest Destiny, the tarnished myth of California as Eden, and man's insignificance in the face of apocalyptic forces. He made a pilgrimage to each facility to gain source material, meet with inmates and define his purpose. I was inspired by his commitment to such a daunting task. As his journey progressed, I grew curious and started my own research on the "prison crisis" facing our community today. Both Sandow and I came across some compelling information.

According to Joseph Hallinan in his book, *Going up the River: Travels in Prisonation* (Random House, 2001), the number of people incarcerated has tripled in sixty years.

> In 1939, 137 Americans went to prison for every 100,000 citizens. By 1999, The US incarceration rate stood at a phenomenal 476 per 100,000. So common is the prison experience in America today that the federal government predicts that one of every eleven men will be imprisoned during his lifetime. For black men, the figure is even higher—more than one of every four. (pg. xiii.)

The United States has more individuals living behind bars than any other country in the world. It is the leader in the industry of incarceration, whose motto is, "What is good for crime is good for the economy." This concept is known as a "twofer." Prisons provide jobs and prevent crime. They pay and they punish. They are built and they are filled.

Prisons are big business and incarceration is a growth industry. More prisons were built in the last twenty years than were built in the entire previous century. Convicts have become clients. Corporations have become investors. Prisons have been privatized.

As with any other business, prisons have become acutely conscious of the "bottom line." Wardens soon discovered the profitability of making pay phones accessible to inmates. Today, prison inmates make over $1 billion dollars worth of collect calls each year; phone companies enable a generous "cut" of this staggering amount to go directly into prison coffers. Profits are also gleaned from selling personal necessities (shampoo, uniforms, toothpaste, shaving cream) to over 1.3 million inmate consumers who have no shopping alternatives.

A relatively new development is the significant increase in Corporate America's use of the prison population as an inexpensive labor force. Prisoners no longer only fabricate license plates or do other manual labor for self-sufficiency; they work for major companies like Eddie Bauer to produce product. In a reverse trend, foreign manufacturing companies have relocated to take advantage of the quality and cost-effective labor American prisoners provide. New prison construction actively encourages this lucrative partnership of commerce and incarceration by incorporating factory facilities in prison compounds.

Criminal legislation feeds the demand for an affordable labor force by increasing criminal penalties for first-time offenders and imposing strict sentencing guidelines that eliminate judge discretion. For example, statistics show that both the Sentencing Reform Act of 1984 and the Anti-Drug Abuse Act of 1986 significantly augmented the prison population—some called it an "industry boom."

Overpopulation in prisons is another aspect of the prison crisis. Crime and abuse committed within prison walls is a breeding ground for more violent and criminal behavior on both sides of the cell.

CALIFORNIA MEN'S COLONY, SAN LUIS OBISPO, CA, 2001

"The funny thing is on the outside I was an honest man—straight as an arrow—I had to come to prison to be a crook" [Andy Dufresne, *The Shawshank Redemption* (Castle Rock Entertainment/Columbia Pictures Corporation, 1994)].

Last March, at a Human Rights Watch luncheon, I listened to Robin Lucas speak about her experience in a woman's federal prison in Dublin, California, in the late-1990s. Formerly a business owner and upstanding member of her community, Robin received a 30-month sentence for a non-violent crime involving her dishonest husband. While serving her sentence, she was brutally attacked by guards in retaliation for complaints she had lodged against them. She received no medical attention for her injuries, and several weeks later she was transferred (illegally) to the men's correctional facility where she was subject to additional attacks. But for her grandmother's persistence in finding her, Robin would have died unknown and uncared for in the men's prison. Her question, "Is this what the judge meant by punishment?"

Sandow's new body of work is a series of paintings and prints. While they may not change the world, these works can (and do) stir emotions, raise questions, and encourage people to find out more about this daunting, unpleasant and unpopular crisis.

Many people have made this exhibition possible. Basil Alkazzi generously funded the publication of this catalog, designed by Ginny Brush of Brush & Associates, with assistance from Armstrong Photolab and Ventura Printing and general support from the Lady Dasher Sojo Fund. Ron Turner from LAST GASP in San Francisco partnered with CAF to publish and distribute the catalog. Darius Spieth and Colin Gardner wrote insightful essays exploring the artistic and philosophical traditions Sandow works within and against while Lorie Porter and Philip Koplin offered editing expertise. Fred Page of Page Art Appraisers, Eleana del Rio and Marti Koplin of Koplin Gallery in Los Angeles, Catharine Clark, Nathan Larramendy and Rochelle Durst of Catharine Clark Gallery in San Francisco all were instrumental in making this show a success.

The first half of this series was exhibited at Koplin Gallery last fall; the second half will be exhibited at Catharine Clark Gallery in November 2001. I am grateful to Greg Escalante for introducing me to Sandow and to all of Sandow's collectors who have entrusted their paintings to CAF so this powerful body of work can be exhibited in its entirety. As usual, the CAF staff and volunteers should be commended for their hard work, dedication and enthusiasm. Finally, thank you to Sandow Birk for bringing to the forefront this complicated and emotional crisis facing our nation. While he did not set out to provide answers, Sandow Birk's art provides tangible evidence of the critical and contradictory issues surrounding crime and punishment in the 21st century.

THE PRISON IN THE GARDEN: Inside Sandow Birk's Topography of Incarceration

By Darius Alexander Spieth
Art Historian and Visiting Scholar at Harvard University's Fogg Museum

There are now around two million American adults incarcerated, a number that is currently being added to at a rate of between 50,000 and 80,000 annually. With an incarceration ratio of 645 per 100,000 of the general population, the United States now imprisons a higher portion of its population than any other Western nation.

The gross numbers are in themselves astonishing; 17 states have smaller populations than America's penal estate. Even at state level the figures are formidable. By itself, California has the largest prison system in the Western world, having grown from around 20,000 in 1977 to 94,000 in 1990 and 159,000 in 1998. Despite an enormous construction program, the state's prisons remain grossly overcrowded and its Department of Corrections estimates that over the next decade $6.1 billion more will be required simply to keep overcrowding at current levels.

–Seán McConville
"The Architectural Realization of Penal Ideas"[1]

Sometime while driving through his home state in search for the subjects of his latest series of paintings Sandow Birk came to the surprising, yet simple realization that California was a land of stunning beauty.[2] This experience was particularly intense and unanticipated since Birk was on the road to explore one of California's more prosaic—not to say disturbing—aspects, the state's sprawling prison system. The paintings of Birk's *Prisonation* series are not artistic fantasies, but part of California's social and economic reality at the end of the millennium. They are realist works in the best sense of the word, yet they document an aspect of reality that is, if anything, surreal.

The subjects from the *Prisonation* series strike the viewer initially by their bold juxtaposition of bucolic landscapes and institutions that cannot fail to evoke a negatively charged, angst-ridden response. The prisons in Birk's paintings only rarely announce their presence overtly. They often get literally lost in the pastoral idyll as the viewer is required to look twice before realizing that these are indeed images of California's thirty-three state prisons nestled in the serenity of rural landscapes. If architecture can ever be apologetic for encroaching on nature, Birk's prison buildings are.

The *Prisonation* series challenges the viewer with a new and thoroughly irreverent interpretation of the long tradition of the pastoral ideal in American art and literature. As Leo Marx has argued in his book *The Machine in the Garden*,

> The pastoral ideal has been used to define the meaning of America ever since the age of discovery [...]. With an unspoiled hemisphere in view it seemed that mankind actually might realize what had been thought a poetic fantasy. Soon the dream of retreat to an oasis of harmony and joy was removed from its traditional literary context. It was embodied in various utopian schemes for making America the site of a new beginning in Western society.[3]

The prison complexes intrude into Birk's pastorals with the same "startling suddenness" as the railways, steamships, or factories

did in nineteenth-century American literature (Nathaniel Hawthorne, Mark Twain, Henry David Thoreau) and painting (George Inness). [4] They attract attention because they introduce a seemingly foreign element evoking feelings of dislocation, conflict, and anxiety. The *Prisonation* series stands in this long tradition of exploring the tension between virginal nature and the brute force of civilization which continued to fascinate American artists for the last one hundred and sixty years. While the prisons are undoubtedly the most obvious intruders in the pastoral idyll, they are complemented by shipyards, power lines, discarded shopping carts, road signs and other paraphernalia of a hyper-mobile, information-based society.

Birk positioned himself very consciously in the venerable tradition of eighteenth- and nineteenth-century landscape painting. We are invited to admire the lush beauty of the vegetation, the enchanting mood of the sunset, or the marvels of atmospheric effects on a wide and open sky. The horror of incarceration is pleasingly

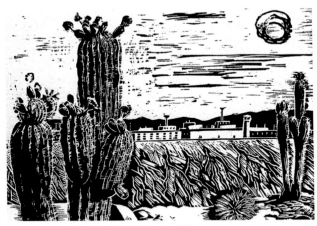

HIGH DESERT STATE PRISON, STANDISH, CA, 2000

absent, if not downright inconceivable, amidst grazing cows, succulent yucca plants, and forgotten mailboxes on a second-order highway. Yet, unobtrusively, it is always present. It resides in the unusual layout of the architectural structures, in the polite admonition not to pick up hitch-hikers, in the metallic glitter of the

fences and in the glaring nighttime illumination strangely out of place in the Romantic scenery.

Despite these tensions, Birk's *Prisonation* images belong to a clearly defined and indeed rather traditional artistic genre. Their iconography makes reference to the "golden age" of Californian landscape painting, the era between 1860 and 1880, when European and East coast artists, inspired by the Hudson River School, discovered California's allegedly pristine wilderness as the new frontier of painting.[5] Artists like Albert Bierstadt, Thomas Moran, or Herman Herzog were awed by the breathtaking vistas of the Yosemite Valley and the Sierra. They found a ready market for the pictures they brought back from their expeditions to the West, as East Coast buyers were already accustomed to the style of their paintings but lacked familiarity with the sites depicted. Not surprisingly, their approach to the Californian landscape subject was profoundly influenced by their own cultural background, which led them to idealize the Yosemite Valley in the same way they had formerly romanticized the Alps, the Pyrenees, or the Hudson River. Their goal was to highlight the "sublime" aspect of the nature experience, a mixture of fear and fascination inspired by God's handiwork. Atmospheric effects, such as the rays of sunlight piercing through the overcast sky in Birk's rendition of the San Quentin prison, were among the pictorial devices most frequently employed to signify a sublime state of mind.

At the same time the allegory of nature as a garden gained ever wider currency. Proponents of the pastoral ideal in the nineteenth century used the garden metaphor in two very distinct ways.[6] In its original sense, the garden came to symbolize an Edenic world of pristine nature untouched by human hands. The serenity of nature's virginal garden, however, already carried with it the prospect of exploration followed by exploitation. Inevitably, a second meaning was assigned to the garden metaphor, which

continues to enjoy the greater currency today: the garden as a cultivated piece of land.

Landscape painting had of course always held the implicit promise of surplus value to be extracted by the landowner. Thomas Gainsborough's late eighteenth-century portraits of England's landed gentry depicted against the landscape backdrop of their estates were nothing but thinly veiled metaphors for the assertion of ownership by an exclusively white and male ownership class.[7] For American writers like Thomas Jefferson, however, the association of the well-groomed European garden with the ideals of the aristocratic leisure-class equaled the anathema of conspicuous display of wealth.[8] As an alternative, they proposed a new "middle landscape," which was to synthesize the ideals of a pristine arboreal wilderness with the civilizing force of horticultural and industrial exploitation of land. From now on the sudden and unexpected appearance of the machine in the wilderness-garden, whether a steam-powered locomotive whistling in the forest or an iron forge huffing in a river valley, made inroads on the poetry of Hawthorne or the paintings of George Inness alike.

In Birk's *Prisonation* series this utopian symbiosis between nature and civilization has come to an abrupt end as prisons have replaced the locomotives or steam boats of the early industrial era. Prisons are indeed Birk's machine, the unwelcome intruders in an otherwise largely untouched landscape. They are the cogs and wheels of the world's highest-density incarceration system, sprawling out over thirty-three state institutions and housing a total of 160,687 inmates as of January 1, 2000 (an increase of +0.7% over the previous year). California today continues to define the benchmarks for incarceration rates (468 per 100,000 California population), prison overpopulation (at 190.3% of design capacity), and prison construction activity.[9] Moreover, Los Angeles County alone holds consistently the largest average daily inmate population of any jurisdiction in the United States (19,931 inmates in 1997).[10]

There are many explanations for the cancerous growth of California's prison system. Some of them have to do with changes in the philosophy of penology and prison management, others with shifts in policy, focusing since the early 1970s increasingly on punishment rather than rehabilitation.[11] An example of how policy changes can affect incarceration rates was the introduction of compulsory urinalysis among parolees and probationers in the late 1980s, which resulted in the identification of thousands of illegal drug users

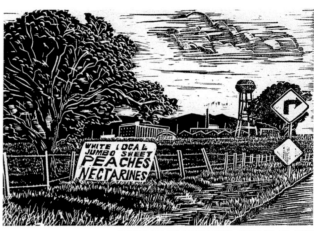

SALINAS VALLEY STATE PRISON, SOLEDAD, CA, 2000

subsequently retained in or returned to jail.[12] Finally, one must account for the specifically Californian ingredients in this recipe, such as the unique role of inner-city street gangs in the demographic profile of the state's prison population.

The core of the system developed from the San Quentin facility, founded in 1851 primarily as a response to the influx of so-called "Sydney Ducks," former Australian prisoners " seeking fortune and promising menace in California."[13] San Quentin was followed in 1878 by the state's first high-security prison, Folsom, housing primarily "long-timers" and recidivists.[14] These two structures

9

formed the backbone of the system until the early twentieth century, when they were complemented by a minimum-security prison for women at Tehachapi in 1932 and a corresponding reformatory for men at Chino in 1936.[15] Between 1944 and 1974 another fifteen correctional institutions were added, including a medium-security facility for men at Soledad.[16] By the mid-1970s it become obvious that California was on a spiral of exponential growth in prison construction. In the decade between 1982 and 1992 alone the state added another twelve institutions to its network, followed by another dozen between 1992 and the end of the millennium.[17] The current planning activities for new prisons or the enlargement of the existing ones suggest that California's prison boom will not end any time soon. Given this development, it is not surprising that the majority of the prisons depicted by Birk date from the last twenty years.

The proliferation of prison structures across California's landscape has its roots in the increasingly fine-tuned methods used to identify, classify, and separate different groups of inmates according to age, gender, and health, as well as nature and severity of criminal behavior. In the period between the founding of San Quentin and the end of World War II, California's prison system had branched out to four institutions, comprising high, medium and minimum security prisons for men and one institution for women. If this taxonomy appears crude by today's standards, it should be recalled that prior to 1878 male and female inmates, the mentally sick, first time offenders, and hardened criminals mingled indiscriminately at San Quentin. [18]

During the heyday of penal rehabilitation between 1950 and 1975 the need arose to add to this system institutions with specific ancillary functions such as schooling, vocational training, or clinical services of social workers, psychiatrists, and psychologists.[19] Examples for such increasingly differentiated structures are the medical and psychiatric facility at Vacaville, opened in 1955, and the federal youth facility at Pleasanton, which dates from 1974.[20]

When the prisons' punitive functions were vindicated in the 1980s, the complexity of the system started to grow along a graded scale of prison security instead of functional diversification. Shifting public attitudes were partly responsible for this change of heart.[21] Californians decided they needed "supersecurity" or "supermax" prisons, especially as news on the "war against crime" focused on a new and thoroughly indigenous criminal: the hardened, ultra-violent gang member. Of course, California had been home to America's foremost high security prison, Alcatraz, for many years before inner-city gangs made their debut in the world's "capital of hyperreality."[22] But Alcatraz was a federal prison without any direct relation to local anxieties. Inefficient and and cost intensive, it was closed in 1963.[23] In contrast, California's two homegrown "supersecurity" prisons, Corcoran and Pelican Bay, are a different kind of animal. They were opened in 1988 and 1989, respectively,

VISITING DAY AT SAN QUENTIN PRISON, 2000

to "sequester disruptive inmates," i. e., the growing population of "gang members who had been particularly violent in other prison settings."[24] Both institutions contain a regular maximum security prison and a "super-supermax" Security Housing Unit (SHU). A typical SHU may consist of twenty-two separate pods on both sides of four five-hundred-foot security corridors in cross form. Each pod has three short wings divided by a partition down the middle to form six separate areas with eight cells facing the dividing wall, four on each level, a total of forty-eight cells. From a control booth in the center of each pod, all the cells can be observed and cell doors operated. Each unit of eight cells has its own exercise yard, ten feet by twenty-six feet, with wire-mesh screen over half of the top and plexiglass over the remainder. Cells have no external light source. Each cell contains a concrete slab for the bed platform and a concrete table and stool integral with the wall and floor next to a stainless steel toilet and wash basin. The two-level connection corridors carry staff traffic above and escorted inmate movement below. Except for those using the law library, inmates are never in groups, even for exercise, feeding, and showering. The SHU prison has been designed for slightly more than a thousand single-occupancy cells. The inmate spends all but an hour a day in his cell.[25]

Despite such ingenuity lavished by California's prison designers on inventing ever new superlatives of security, most of the state's recently built prisons are strictly minimum-security institutions. This development has been in line with recent penological theory aimed at replacing riot-prone, high-capacity prisons with smaller, dispersed units that are easier to control in the event of a crisis. A look at San Quentin's prison mess hall, where as many as eighteen hundred men could be fed in a single sitting, explains the demise of prisons concentrating huge inmate populations.[26] As the number of prison institutions across the state grew, however, the need to improve the economic management of the system became more pressing. In response to these constraints the California Department of Corrections started to adopt in the 1980s two standard plans for all newly built prisons, modeled after the low-security units of either the Pelican Bay or the Sacramento facility.[27]

Besides the standardization of layout, cost savings in a minimum- and medium-security environment could also be accomplished by using cheaper construction materials.[28] For the outside observer this trend manifests itself mainly in the disappearance of costly prison walls, which were replaced among the newer structures with fences secured by electronic sensing, or, in some instances, electrical charges. In many of Birk's paintings these fences have indeed become the most prominent signifier of the prison institution, giving the structures a distinctly foreign and mechanical feel within the context of their nature setting.

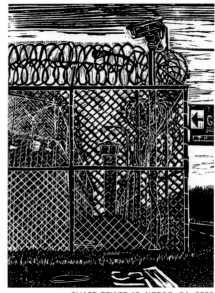

GUARD TOWER #2 NORCO, CA, 2000

In an almost surreal twist to California's prison story, the electrically charged fences at Calipatria State Prison drew criticism from an unlikely alliance of environmentalists and prison guards.[29] While the Audubon Society expressed concern over the rising death toll among local waterfowl and rodents electrocuted by human-strength voltage, prison guards felt that the cozier sharpshooting positions in the watch towers might be rationalized away if all the state's prison system were managed exclusively by Southern California Edison. A detailed environmental impact study, followed

by the even more costly installation of the world's "only birdproof, ecologically responsible death fence" could at least palliate the ornithologists.[30]

As this example demonstrates, many of California's prisons exist indeed in a very real antithetical relationship to their natural surrounding. In this sense they are worthy successors to the nineteenth-century steam engines disrupting the quiet of the primeval forest. But prisons also hold a very specific place in the social order of Southern California and it is this place more than anything else that determines their uneasy relationship with their biosphere.

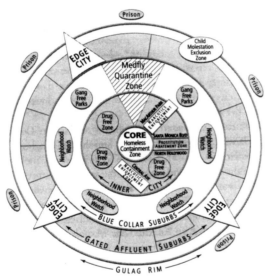

Ecology of Fear

As Mike Davis pointed out, California's prisons form the outer "Gulag Rim" of Los Angeles's "Ecology of Fear." In his analysis of Southern Californian urban development patterns Davis suggested a darkly ironical reconfiguration of a model originally proposed by University of Chicago sociologist Ernest W. Burgess in the 1920s.

Both Davis and Burgess conceive of the city in terms of a series of concentric circles occasionally interspersed with wedge-shaped enclaves. Davis replaced Burgess's downtown Loop with a "Homeless Containment Zone," surrounded by an inner city ring of "Drug Free Zones," "Narcotics Enforcement Areas" (Central Avenue, MacArthur Park), and "Prostitution Abatement Corridors" (Santa

Monica Boulevard, North Hollywood). Burgess's circles III ("Zone of Workingmen's Homes") and IV ("Residential Zone") metamorphose into Davis's "Blue Collar Suburbs," replete with "Neighborhood Watch Areas" and "Gang Free Parks," merging gradually into the "Gated Affluent Suburbs" district, where "Edge Cities" rub shoulders with a "Child Molestation Exclusion Zone." The most thorough transformation of Burgess's spatial order, however, occurs in the outermost zone V ("Commuter Zone" with "Bungalow Sections"), which Davis substituted by a "Gulag Rim" of evenly distributed prison institutions.

Davis's scheme casts a revealing light on the place of prisons in California's social structure, which is vividly expressed by their assigned physical space. Prisons are literally marginalized in this order and removed from the visual consciousness of the city that feeds them with their inmates. Of course, prisons and residential areas never co-existed well, whether in California or elsewhere.[31] Construction plans for new prisons inevitably incite the ire of local middle-class homeowners in fear of their personal safety and alarmed by the drop of land prices due to the ungainly incarceration machine in their gardens. In most instances, the only solution to this dilemma is to construct prisons outside the purview of the middle-classes, which partly explains the seemingly bucolic settings in many of Birk's vistas.

The predominant choice of rural sites for California's prisons, however, also has roots in the state's long tradition in the commercialization of incarceration. Prisons in California have always been big business. San Quentin was founded as a for-profit franchise by the entrepreneurs Marino Guadalupe Vallejo and James Madison Estell; the land for Folsom prison was bought with $15,000 worth of convict labor from the Natoma Water Company (later Sacramento Electric, Gas and Railway Company).[32] Even today, California's prison industries, contracted primarily by the U. S. mil-

itary, are second only to New York's, while the state remains at the forefront of prison privatization.[33] The exploitation of prison labor was always seen as the greatest asset in making jails financially self-sustaining institutions independent from tax contributions. To minimize expenses and maximize profits, institutions like Soledad were conceived as farming factories, where inmates with lighter sentences would cultivate the surrounding fields to sustain themselves and those working in the prison industries.[34] Moreover, farming was widely perceived as an efficient rehabilitation measure that promised salutary effects on inmate discipline. If many images of the *Prisonation* series have a distinctly agrarian flavor to them—Wasco State Prison, the North Kern State Prison at Delano, or the California Rehabilitation Center at Norco— it may be exactly because many of California's prisons doubled as farms.

The proliferation of prison institutions, the rapid growth of the inmate population, and the relative scarcity of capital punishment combined with shorter average sentences have conferred a sense of normalcy to incarceration in the Golden State. In her study about Crime and Punishment in California Joan Petersilia found that forty percent of youths detained in state training schools in 1988 reported that their parents also had been incarcerated and that a quarter of all males living in U. S. inner cities will spend time in jail at some point in their lives. From this she concluded that "the stigma attached to having a prison record in these high-crime neighborhoods may not be as great as it was when prison terms were less common," especially since "many of the offender's peers and other family members have also done time."[35] It is a telling sign that prison administrators struggle with inexplicable "shrinkage" of prison clothing because former inmates enjoy wearing the uniforms in their neighborhoods after release to make fashion statements or to proudly announce their newly acquired social status.

This "normalization" process of incarceration represents indeed the final step of an evolution outlined in Michel Foucault's landmark book *Discipline and Punish*. For Foucault, coercive and disciplinary structures have encroached since the early seventeenth century with increasing efficiency on behavior patterns and social norms both in- and outside the immediate purview of the justice system.[36] Hence, Foucault's inmates became broken and submissive "docile bodies" in a society with a fluent transition between prisons and the civilian "outside." The Californian experience teaches us that mass incarceration may mitigate the prison institution's dark symbolic meaning when boredom replaces shame and "doing time" becomes simply a rite of passage. Most recent prison architecture has taken this reconfigured status of normalization into account, since "some new prisons look more like civilian structures both inside and out than custodial institu-

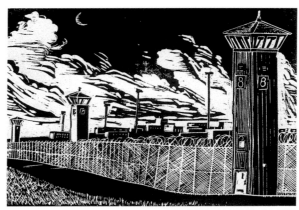

PLEASANT VALLEY STATE PRISON, COALINGA, CA, 2000

tions."[37] Commenting in a similar vein on the Los Angeles Metropolitan Detention Center completed in 1988, Alexander Cockburn remarked that "life being mostly a matter of resting up after coming from somewhere while waiting to go someplace else, the airport terminals, hotels, and jails of the twenty-first century will all blend into one form, very well evinced in this ten-story jailhouse [...] You wouldn't be ashamed to have your mother come looking for you here, not the way you would at the old county jail a mile to the east."[38] California's "normalized" twenty-first-century

topography of incarceration resonates as a dystopian, yet strangely mellifluous coda to the "middle-landscape" dreamed of by nineteenth-century Romantics.

The ritualized logic linking crime and punishment is so widely accepted that few people dare to question the Faustian pact modern surveillance societies strike with their prison institutions. But every society, consciously or unconsciously, does make a choice whether to punish and how to punish. Sandow Birk's *Prisonation* series gives us insights into the choices Californians made for their society and provides us with a starting point to critically analyze and candidly discuss the difficult legacy of uncontrolled prison growth.

NOTES:

1. Seán McConville, "The Architectural Realization of Penal Ideas," in *Prison Architecture: Policy, Design and Experience*, eds. Leslie Fairweather and Seán McConville (Oxford and Boston, 2000), 1.

2. Interview with Sandow Birk by the author, Museum of Modern Art, New York, December 7, 2000.

3. Leo Marx, *The Machine in the Garden: Technology and the Pastoral Ideal in America* (New York and Oxford, 1964), 3.

4. Ibid., 15.

5. Nancy Dustin Wall Moure, *California Art: 450 Years of Painting and Other Media* (Los Angeles, 1998), 39-49. The notion that California's landscape was a pristine wilderness when white settlers and, in their retinue, painters like Bierstadt arrived has been discredited by Mike Davis, who pointed out that native Americans had changed the physical appearance of the West Coast through "selective fire farming" long before. Mike Davis, *Ecology of Fear: Los Angeles and the Imagination of Disaster* (New York, 1998), 209-10.

6. Marx, 84-5.

7. John Barrell, *The Dark Side of the Landscape: The Rural Poor in English Painting, 1730-1840* (Cambridge and New York, 1980), 35-48; Ann Birmingham, *Landscape and Ideology: The English Rustic Tradition, 1740-1860* (Berkeley and London, 1986), 16-17.

8. Marx, 92-93, 112-4, 121-2.

9. California Department of Corrections, California Prisoners & Parolees 2000 (Sacramento, 2000), n. p. ("Highlights" and Table 6). One needs to differentiate between the "Institution Population," cited here, and the whole "California Department of Corrections Population," including, among others, parolees, federal prisoners, and escapees, which numbered 303,657 on January 1, 2000. Over the calendar year 2000, the incarceration rate dropped slightly for the first time since 1977, when it stood at 86.8 inmates per 100,000 population. The growth rate of "Institution Population" had been consistently higher in the 1990s than it was in 2000: +4.7% (1993/94), +7.7% (1995/96), +2.8% (1997/98).

10. U. S. Department of Justice, Correctional Populations in the United States, 1997 (Washington, D.C., 2000), 23 (Table 2.8). Los Angeles County was followed by New York City (19,205) and Cook County, IL (9,100).

11. Joan Petersilia, "Crime and Punishment in California: Full Cells, Empty Pockets, and Questionable Benefits," in *Urban America: Policy Choices for Los Angeles and the Nation*, eds. James B. Steinberg, David W. Lyon et al. (Santa Monica, CA, 1992), 175-90.

12. Ibid., 190.

13. Shelly Bookspan, *A Germ of Goodness: The California State Prison System, 1851-1944* (Lincoln and London, 1991), 1.

14. Ibid., 49.

15. Ibid., 69-110.

16. Ibid., 116-8.

17. Petersilia, 179.

18. Bookspan, 18, 28.

19. Norman Johnston, *Forms of Constraint: A History of Prison Architecture* (Urbana and Chicago, 2000), 148.

20. Ibid., 152-3.

21. Petersilia, 175-6.

22. Davis, 392.

23. Johnston, 144.

24. Ibid., 157.

25. Ibid., 157-8.

26. Ibid., 160-1. See also the photo of San Quentin's prison mess hall in Figure 113.

27. Ibid., 154.

28. Ibid., 148.

29. Davis, 411-3.

30. Ibid., 412.

31. For an example of how grassroot neighborhood protests prevented in 1917 a prison from being build in Napa County, near Yountsville, see Bookspan, 97.

32. Ibid., 2, 41; David Shichor, *Punishment for Profit: Private Prisons/Public Concerns* (Thousand Oaks and London, 1995), 39-41.

33. United States Senate, *Committee on the Judiciary, Bureau of Prisons Oversight: The Importance of Federal Prison Industries* (Washington, D.C., 2000), 2-3, 22-4; Charles H. Logan, *Private Prisons: Cons and Pros* (New York and Oxford, 1990), 20-2, 28. Both the INS and the RTC (Return-To-Custody) program for parole violators contract private prisons in California today.

34. Bookspan, 116.

35. Petersilia, 197.

36. Michel Foucault, *Discipline and Punish: the Birth of the Prison*, trans. Alan Sheridan (New York, 1995), 135ff.

37. Johnston, 160.

38. Alexander Cockburn, "On the Rim of the Pacific Century," in *Sex, Death and God in L.A.*, ed. David Reid (Berkeley and London, 1994), 9.

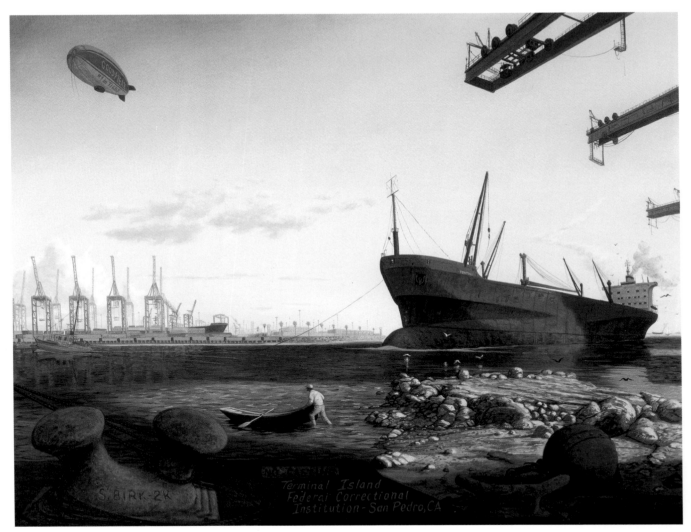

TERMINAL ISLAND FEDERAL CORRECTIONAL INSTITUTION, SAN PEDRO, CA, 2000

16

CONSTRUCTING THE CARCERAL LANDSCAPE: Colonial Discourse and Manifest Destiny in Sandow Birk's Prisonation Series

by Colin Gardner
Assistant Professor of Art Theory and Criticism, University of California at Santa Barbara

Colonization = 'thingification.' - Aimé Césaire

In his Discourse on Colonialism, the Martiniquan writer and political activist Aimé Césaire proposed that Adolf Hitler's real historical crime had been to humiliate the white man in the same way that the white man had humiliated the colonized Other.

After all, had not Hitler and the Nazis subjugated Europe with the same barbarism masquerading as Manifest Destiny — based on the same racist ideology of Aryan superiority — that the "enlightened" democratic European nations had imposed on their own colonial subjects? With convincing logic, Césaire argued that before they were its victims, the western colonial powers — and we may include the United States' treatment of Native Americans in this indictment — had been Nazism's accomplices, "that they tolerated that Nazism before it was inflicted on them, that they absolved it, shut their eyes to it, legitimized it, because, until then, it had been applied only to non-European peoples."[1]

Although, as Michel Foucault has pointed out, we can never know our own era's cultural archive or discursive practices because they are the ineffable political unconscious from which we speak, we can begin to understand (and retrospectively construct) an earlier archive by distancing ourselves from the historical past's prevailing epistemic assumptions. Viewed through this more opaque and refracted post-colonial prism, the horror of Nazism helps us defamiliarize and deconstruct the transparent, self-evident truths of Enlightenment humanism all the better to disclose the Caucasian, western conception of the "Rights of Man" as "narrow and fragmentary, incomplete and biased and, all things considered, sordidly racist."[2] In his *Prisonation* series, Sandow Birk employs a similar alienating strategy — what the German playwright Bertolt Brecht called *Verfremdungseffekt* — for similar ideological ends. By rendering all thirty-three prisons within the California penal system through the naturalist discourse of 19th-century American landscape painting — itself based in late 18th- and early 19th-century European theories of the beautiful, the sublime, and the picturesque — Birk decenters the ideology of western pictorial values by estranging us from the signifiers of our own historical (read: colonial) self-representation. Far from propagating the post-bellum expansionist myth of California and the other western states as a pre-ordained American Eden just waiting to be discovered and exploited, Birk's paintings of the *Correctional Training Facility at Soledad* (rendered in the luminist style of Frederic Edwin Church), and the State Prison at Coalinga, with its bucolic Hudson River School setting, force us to see the naturalized forms of the late-Romantic pastoral landscape as a constructed language of self-deluding rhetoric that effectively masks a more sinister ideological predilection for incarceration, surveillance and panoptic control.

In Birk's hands, the language of naturalism, which marks the "golden age" of Californian landscape painting, is unveiled in its true colonial colors. The "untamed" wilderness is not merely trans-

formed into a cultivated garden through the representational tropes of the picturesque and painterly sublime but, more importantly, as a signifier of the expansion of European culture and civilization through its transformation from collective Native American tribal land — steeped in religious and ritual significance — to secular private property. In this context, the prison is metonymically connected with the institutionalization of property as the defining norm of capitalist investment and speculation, for as Foucault argues, "The carceral network, in its compact or disseminated forms, with its systems of insertion, distribution, surveillance, observation, has been the greatest support, in modern society, of the normalizing power."[3] Against this norm, the ancient "illegality of rights, which often meant the survival of the most deprived, tended, with the new status of property, to become an illegality of property. It then had to be punished."[4]

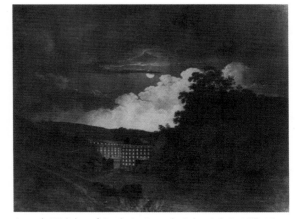

Joseph Wright of Derby's *Joseph Arkwright's Mill, View of Cromford, near Matlock,* 1783

Birk's choice of 19th-century landscape models is thus wholly appropriate for an investigation of the western myth gone sour, for the form is synonymous with the "romantic nationalism" that defined the barbarous colonial project in the first place. Between the late 1860s and the 1880s, painters and photographers regularly accompanied the Government-sponsored geological surveys of western deserts and mountains — the most famous being Clarence King's 40th Parallel Survey (later to become formalized as the United States Geological Survey after 1879) — as well as the western expansion of the transcontinental railroad. W.H. Jackson's photographs of Yellowstone, Carleton E. Watkins and Eadweard Muybridge's recordings of Yosemite, Timothy O'Sullivan's images of geological striations and monuments in the Rocky Mountains and Sierra Nevada, were not just aesthetic framings of the awe-inspiring sublimity of the natural landscape but actively assisted the scientific aims of the survey teams by recording virgin nature as something readable, measurable and nameable as a concrete sign, thereby making it readily commutable for eventual economic and ethnographic exploitation.

Conveniently omitted from official consideration (and representation) were the civil and human rights of the original occupants of the western territories, the Native Americans themselves. According to Alan Trachtenberg, "The conflict of law and interest between the expanding American nation and the defensive Indian nations arose from cultural antagonisms as well as economic interest. John Wesley Powell, director of one of the surveys, observed that native peoples viewed the land in a manner much different from that embodied in the survey: land was not an exploitable resource available for private ownership; it was collective property, the medium of communal life."[5] By riding roughshod over existing Indian names, the surveys' mapping and nomenclature was tantamount to an act of trespass against their sacred rites. Josiah Dwight Whitney, head of the California Geological Survey of the Yosemite Valley, typified the sense of entitlement of the prevalent colonial discourse when he argued: "We have … a full and ample right as the first explorers, describers and mappers of the High Sierra, to give such names as we please to the previously *unnamed* [my italics] peaks which we locate."[6]

This colonial naming and maiming is complemented by the viewing experience provided by paintings and photographs, which create a

conceptual bridge between abstract and concrete visual modes of experience. If we expand this original colonial discourse to California's modern carceral archipelago, Birk's *Prisonation* series acts as a parodic synecdoche of capitalism's stake in preserving the rights of private property against the deterritorializing lines of flight synonymous with indigenous communal practices. Because Birk's prisons are visually self-abnegating —they are often so well integrated into the natural landscape that they are often barely perceptible—they subtly underline the power of the normalizing discourse to absorb the institutional mark of transgression into the representational schema of the dominant episteme. In this respect, the modern prisoner as a transgressor of the right of/to property can be said to stand in for the original resistance to the government-sanctioned rape of the American wilderness: namely, the (absent) historical role of the Native American. Birk's paintings thus tease out the ideological signifiers of colonialism by overdetermining its visual and ideological tropes. The more the paintings represent a normalized, carceral ontology, the more they draw attention to its suppressed and absent Other.

Although they fulfilled the exigencies of objective documentation befitting a geological survey, many of the original photographic and painted views of the West followed the pictorial conventions of the pastorale and the picturesque established in Europe at the end of the eighteenth century. According to Trachtenberg, "The evidence is strong that survey geologists viewed photography as both accurate, and thus useful in conveying the appearance of specimens and formations, and beautiful, capable of winning the public's attention and, not incidentally, renewed appropriations from Congress."[7] Clarence King's theoretical work, *Systematic Geology* (1978), for example, is rife with descriptive references to the "picturesque" landscape or "picturesque evidence" in his recordings of rock formations and river valleys, suggesting a direct synthesis between scientific observation and aesthetic pleasure.[8]

But what exactly is the ideological nature of the picturesque pastorale and how does it fit in with the colonial (and Birk's postcolonial) project? The first recognized study of the picturesque was William Gilpin's 1803 publication, "Three Essays: On Picturesque Beauty; On Picturesque travel; and On Sketching Landscape." It was here that Gilpin laid down many of the principles that define Birk's appropriated visual language, specifically a predilection for roughly-hewn rock formations (as opposed to smooth, undulating topographies), and the precarious ephemerality of natural phenomena such as sunsets and storm systems that typify the romantic tropes of the latter's sublime depiction of the California Correctional Center at Susanville. More importantly, Gilpin stressed the cultural (i.e., constructed) nature of the picturesque. "Applied to landscape, the term picturesque referred to its fitness to make a picture," states Ann

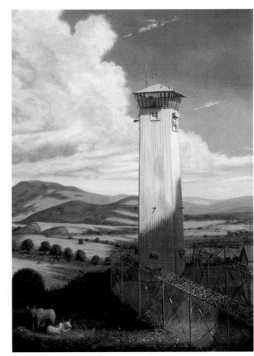

ATASCADERO STATE HOSPITAL FOR THE CRIMINALLY INSANE, ATASCADERO, CA, 2000

Bermingham. "Applied to pictures, the term referred to the fidelity with which they copied the picturesque landscape. If the highest praise for nature was to say that it looked like a painting, the highest praise for a painting was to say that it resembled a painterly nature."[9] This tautological definition is a perfect alibi for the form's normalizing procedures, for it serves to naturalize and institutionalize in equal measure without making the contrivance seem

at all obvious. In short, "the picturesque's ideal is essentially static…it aims to freeze and contain."[10] One might also add, that it aims to reify, i.e., to turn everything into an exploitable and ultimately exchangeable object or thing.

However, this reification is at the same time contradicted by the picturesque's equal acknowledgement and exploitation of the ravages of time. It's no accident that the picturesque became a fashionable mode of representation just as the bucolic Eden of Europe's pastoral past was rapidly giving way to the incursions of the agricultural and industrial revolutions. Although on certain levels the picturesque became a nostalgic, often hermetic refuge from the scarring effects of technological change, it also marks an aesthetic response to some of its more Dante-esque effects, attempting to acknowledge and even assimilate the ravages of time and industrial blight on the pastoral landscape in a more ambivalent form. Heavily influenced by the 17th-century landscapes of

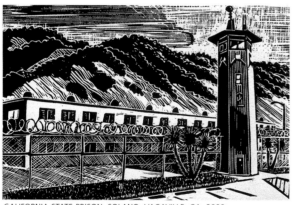

CALIFORNIA STATE PRISON, SOLANO, VACAVILLE, CA, 2000

Claude, "the compositional stamp of the 'pastorale' carried with it an elegiac sense of Eden, and on this tired reference viewers could heap a burden of meaning which had to do with American nature as a garden, with ideal nature as a locus between wilderness and culture that could accommodate man's intrusion."[11]

The early resistance of the picturesque to the overpowering effects of the industrial revolution led to the development of a new indus-

trial genre of landscape painting in an attempt to naturalize industry's "dark Satanic mills" by assimilating them into the unspoiled natural environment. Arthur Young's 1785 description of the Coalbrookdale factories, for example, attempts a synthesis of the natural and the man-made analogous to romantic and sublime landscapes of the period: "The noise of the forges, mills, & c. with all their vast machinery, the flames bursting from the furnaces with the burning of the coal and the smoak [sic] of the lime kilns, are altogether sublime, and would unite well with craggy and bare rocks…"[12] An even better example, perhaps, given Birk's synthesis of the bucolic with the panoptic and carceral, is Joseph Wright of Derby's series of paintings of Richard Arkwright's cotton mills at Cromford, near Matlock, England. In *Arkwright's Mill, View of Cromford, near Matlock* (c1783) nature sustains its integrity in the foreboding presence of the factory, which is rendered like a stately country house, as if the newly emerging industrial bourgeoisie had earned the same natural entitlement and stake in "England's pleasant pastures" as their aristocratic cousins. Not surprisingly, the work engendered an ambivalent response, as seen in this 1790 account from the Hon. John Byng, later the 5th Viscount Torrington:

> Speaking as a tourist, these vales have lost all their beauties; the rural cot has given place to the lofty red mill, and the grand houses of overseers; the stream perverted from its course by sluices and aqueducts, will no longer ripple and cascade —Every rural sound is sunk in the clamor of cotton works, and the simple peasant (for to be simple we must be sequester'd) is changed into the impudent mechanic 'These cotton mills, seven stories high, and fill'd with inhabitants, remind me of a first rate man of war; and when they are lighted up, on a dark night, look most luminously beautiful'."[13]

This delicate balance between the transcendental qualities of the wilderness and the manifest destiny of man's materialist appropriation of it for his own industrial needs, plays out in a more integra-

tive form in the landscapes of the Romantic sublime, which Birk takes as his chief painterly model. In the American context, the genre includes the luminist works of English-born Thomas Cole, Asher B. Durand, Albert Bierstadt, Fitz Hugh Lane, Martin Johnson Heade, Thomas Moran and Frederic Church. A good example of what we might call "technological pastoralism" is Durand's *Landscape, Progress* (1853). In this case, an imaginary Hudson River Valley landscape is seamlessly integrated with the modern industrial presence, signified by railway viaducts, telegraph poles, steam ships and developing townships. Significantly, the distant scene is observed by a tiny pair of Native Americans, dwarfed in the picture's immediate foreground. "The inclusion of the Indian figures brings an historical aura to the landscape of promise and settlement; they are, quite literally, history," states Brian Lukacher. "The beholder's point of view is aligned to that of the Indians, but only to give greater distance to the spectacle of national power and its pleasurable integration within the natural order. The fateful note of sentiment sounded for the vanishing Indian race is overcome by, and predicated on, the prospective master of the vista in which the viewer is meant to take pride."[14]

Like Birk's *Prisonation* series, much of this work sets up an ambivalent, Janus-faced image, sanctifying the past in the form of the indigenous Indian culture through antiquaries in the natural landscape — altar-like rock formations, ritual stones, clumps of trees, etc. — but also looking to the future: America as a new promised land of commercial and tourist development, with its necessary corollary of hidden panoptic surveillance. Birk's Claude-like rendition of the San Quentin State Prison, for example, relegates the penal colony to the hazy distance of a bucolic lakeside scene. The artist structures the landscape as a series of perspectival steps, moving from foreground to background, bottom to top. We start with the shoreline in the immediate bottom foreground, whose shallow curve leads the eye to the picture's middle ground, which features a craggy rock face climbing the right-hand side of the pic-

ture, and a dark line of trees, starkly silhouetted against the sky and jutting into the center of the composition. It's here that we latch onto a vertical smudge of gray that links us to the work's focal point, namely a radiating series of storm clouds that threaten to engulf the landscape in a cataclysmic Armageddon. However, a more sustained viewing discloses a different form, appearing ghost-like from the atmosphere. The storm clouds seem to be metamorphosing into a giant lighthouse, or more ominously, a blinding searchlight, as if the sublime form of the romantic landscape had discovered its carceral corrollary lurking immanently within its painterly depths.

The reification of nature is not only frighteningly complete, but we have discovered the means of its colonization both literally and figuratively within its own manifest destiny. Much like Church's *Twilight in the Wilderness*, Birk empties out the overt visible signs of both colonizer and colonized from the landscape. Instead, we are left with the apotheosis of

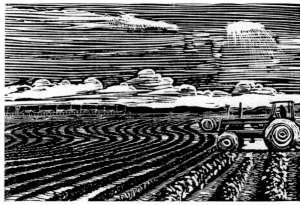

CALIFORNIA STATE PRISON, CORCORAN, CA, 2000

the sublime, carefully balancing the awesomeness of divine providence with a potentially violent, turbulent apocalypse. The landscape simply awaits the presence of Man (i.e., western, civilizing, carceral Man) to transform the potential fury of one into the docile bodies of the other/Other.

NOTES:

1. Aimé Césaire, "Discourse on Colonialism," in Patrick Williams and Laura Chrisman, eds., *Colonial Discourse and Post-Colonial Theory: A Reader*, New York: Columbia University Press, 1994, p. 174.

2. Ibid.

3. Michel Foucault, *Discipline and Punish: The Birth of the Prison*, trans. Alan Sheridan, New York: Vintage Books, 1979, p. 304.

4. Ibid, p. 85.

5. Alan Trachtenberg, *Reading American Photographs: Images as History, Mathew Brady to Walker Evans*, New York: Hall and Wang, 1989, p. 125.

6. Ibid, p. 127.

7. Ibid, p. 131.

8. Ibid, p. 132.

9. Ann Bermingham, *Landscape and Ideology: The English Rustic Tradition, 1740-1860*, Berkeley & Los Angeles, University of California Press, 1986, p. 57.

10. Anne Hollander, *Moving Pictures*, Cambridge, Massachusetts: Harvard University Press, 1991, p. 263.

11. Barbara Novak, "Landscape Permuted: From Painting to Photography," in Vicki Goldberg, ed., *Photography in Print*, Albuquerque: University of New Mexico Press, 1981, p. 173.

12. Cited in Bermingham, op cit, pp. 79-80.

13. Cited in Benedict Nicholson, *Joseph Wright of Derby: Painter of Light*, London: Routledge and Kegan Paul & New York: Pantheon Books, 1968, p.167.

14. Brian Lukacher, "Nature Historicized: Constable, Turner, and Romantic Landscape Painting," in Stephen F. Eisenman, ed., *Nineteenth Century Art: A Critical History*, New York & London: Thames and Hudson, 1994, p. 143.

In the course of the this project a few individuals have been remarkable and deserve special mention: I would like to thank to Basil Alkazzi for his extremely generous support and continued belief in my work; Meg Linton, for her hard work in organizing the exhibition and publication and for her enthusiasm throughout; Catharine Clark for her early support of the concept; Darius Spieth for his enthusiasm; Colin Gardner for his early thoughts on the project; the Koplin Gallery for their support and belief in my work; artist Mark Housley, for his early support and participation in various stages of the project; David Beck-Brown for his assistance and unprecedented access to prison and prisoners; and finally, to Scott, Swanie, Orlando, Limpy, and all the men in cellblock 81, Yard 2, of the Richard J. Donovan Correctional Facility in San Diego. May your time fly.

Vita longa, ars brevis
Thank you all.
– Sandow Birk

"Freedom is what you do with what's been done to you."

- Jean-Paul Sartre

CALIFORNIA STATE PRISON SECURITY LEVELS:

RC Reception Center to receive and process newly committed felons
I Open dormitories with no fence
II Open dormitories with fences and armed guards
III Individual cells, fences, and armed guards
IV Cells, fenced or walled perimeters, electronic security, armed guards
 inside and out
PHU Protective Housing Unit (to isolate prisoners in danger from other prisoners)
PSU Psychiatric Services Unit (within an SHU)
EOP Enhanced Outpatient Program (for PSU)
SHU Security Housing Unit, or "Maximum Security"
COND Condemed (Death Row)

All numbers from California Department of Corrections report as of December 2000.

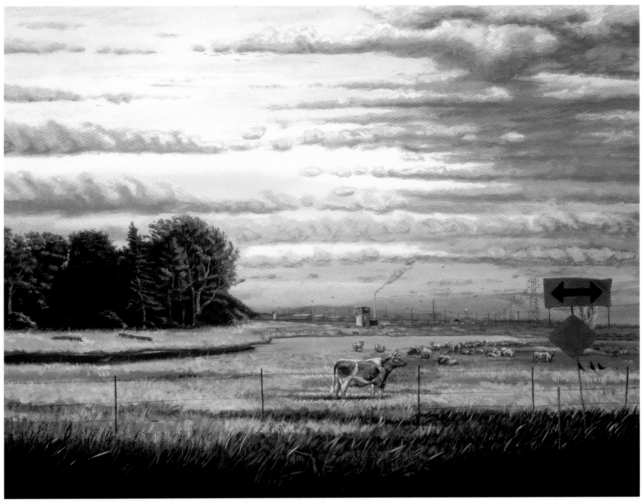

CALIFORNIA INSTITUTION FOR WOMEN (CIW) - FRONTERA, CA

Opened: 1952	120 Acres
Security Levels:	I, II, III, and IV
Yearly Operating Budget:	$42 million
Total Staff:	656
Total Design Capacity:	1,026
Dec. 2000 Inmate Population:	2,107

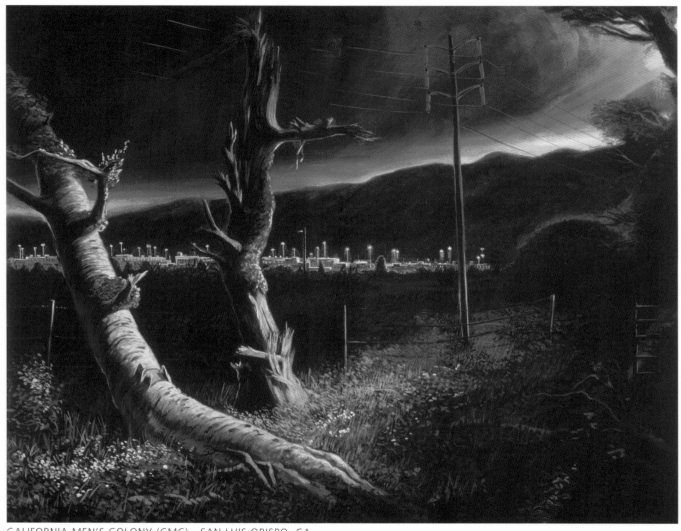

CALIFORNIA MEN'S COLONY (CMC) - SAN LUIS OBISPO, CA

Opened: 1954, expanded 1961	356 Acres
Security Levels:	I, II, III
Yearly Operating Budget:	$ 128 million
Total Staff:	1,646
Total Design Capacity:	3,884
Dec. 2000 Inmate Population:	6,725

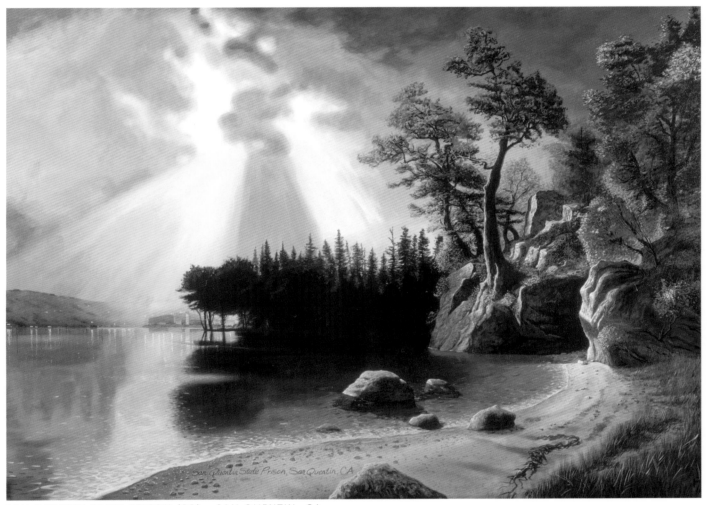

San Quentin State Prison, San Quentin, CA

SAN QUENTIN STATE PRISON (SQ) - SAN QUENTIN, CA

Opened: 1852	432 Acres
Security Levels:	I, II, RC, COND
Yearly Operating Budget:	$ 120 million
Total Staff:	1,548
Total Design Capacity:	3,417
Dec. 2000 Inmate Population:	6,121

Note: California's oldest and most infamous prison, it is the only place of execution in the state. It currently houses all male Death Row inmates.
Total Executions at San Quentin: 420 (215 hanged, 196 gas, 9 lethal injection)

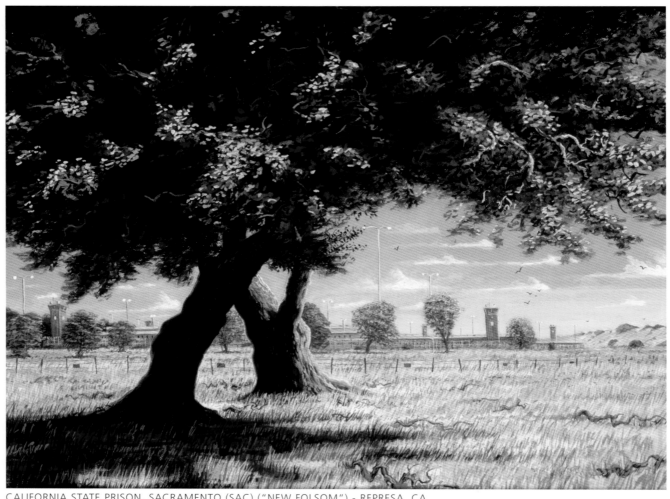

CALIFORNIA STATE PRISON, SACRAMENTO (SAC) ("NEW FOLSOM") - REPRESA, CA

Opened: 1986	1,200 Acres
Security Levels:	I, IV, PSU, and EOP
Yearly Operating Budget:	$ 80 million
Total Staff:	1,158
Total Design Capacity:	1,728
Dec. 2000 Inmate Population:	3,266

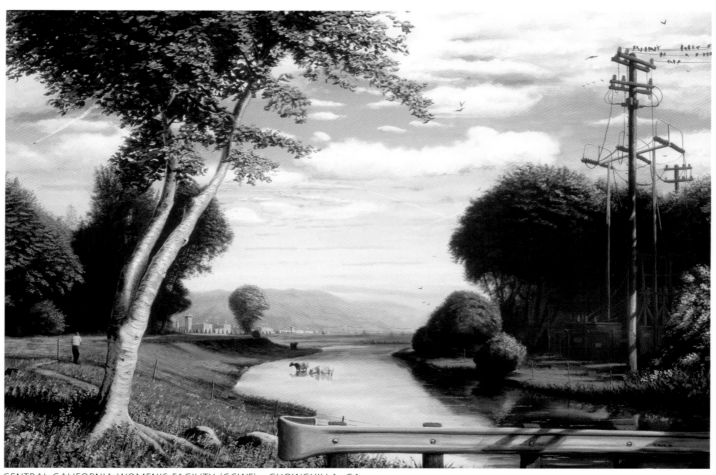

CENTRAL CALIFORNIA WOMEN'S FACILITY (CCWF) - CHOWCHILLA, CA

Opened: 1990	640 Acres
Security Levels:	I, II, III, IV and RC
Yearly Operating Budget:	$ 75 million
Total Staff:	969
Total Design Capacity:	2,004
Dec. 2000 Inmate Population:	3,416

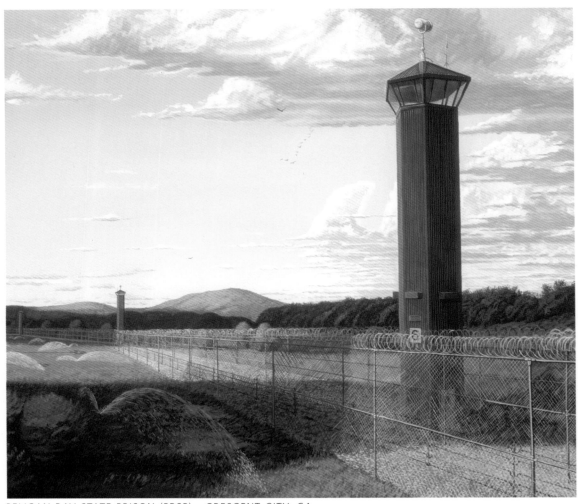

PELICAN BAY STATE PRISON (PBSP) - CRESCENT CITY, CA

Opened: 1989	275 Acres
Security Levels:	I, IV and SHU
Yearly Operating Budget:	$ 83 million
Total Staff:	1,317
Total Design Capacity:	2,280
Dec. 2000 Inmate Population:	3,384

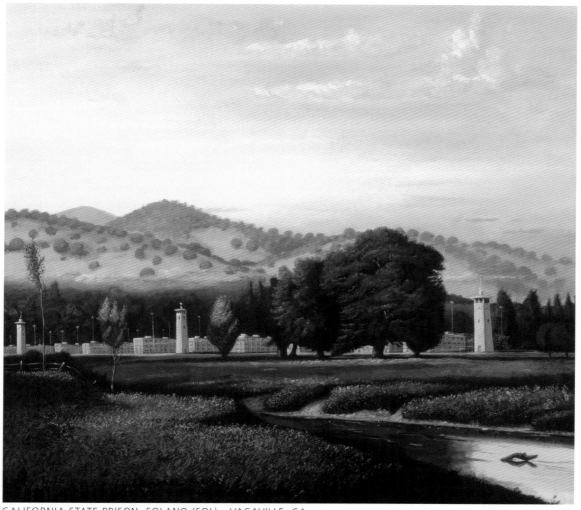

CALIFORNIA STATE PRISON, SOLANO (SOL) - VACAVILLE, CA

Opened: 1984	146 Acres
Security Levels:	I and III
Yearly Operating Budget:	$ 84 million
Total Staff:	1,280
Total Design Capacity:	2,110
Dec. 2000 Inmate Population:	5,811

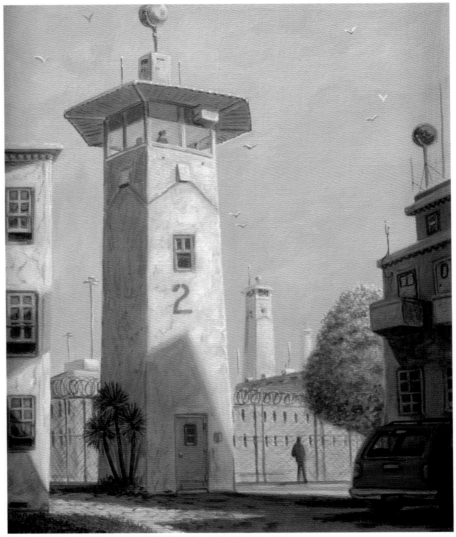

CALIFORNIA MEDICAL FACILITY (CMF) - VACAVILLE, CA

Opened: 1955	600 Acres
Security Levels:	I, II, and III
Yearly Operating Budget:	$110 million
Total Staff:	1,374
Total Design Capacity:	2,315
Dec. 2000 Inmate Population:	3,027

Note: Medical and psychiatric institution for male felons from around the state.

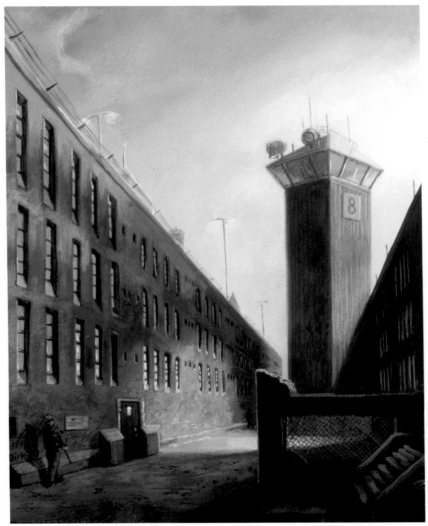

Opened: 1997
Security Levels:
Yearly Operating Budget:
Total Staff:
Total Design Capacity:
Dec. 2000 Inmate Population:

280 Acres
II, III, IV and SATF
$ 101 million
1,550
3,324
6,239

CALIFORNIA SUBSTANCE ABUSE TREATMENT FACILITY AND STATE PRISON (SATF) -
CORCORAN, CA

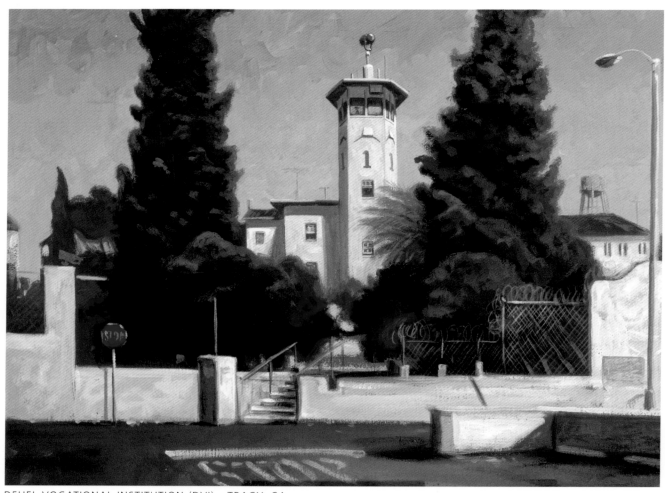

DEUEL VOCATIONAL INSTITUTION (DVI) - TRACY, CA

Opened: 1953	783 Acres
Security Levels:	I, III, and RC
Yearly Operating Budget:	$ 68 million
Total Staff:	1,016
Total Design Capacity:	1,787
Dec. 2000 Inmate Population:	4,136

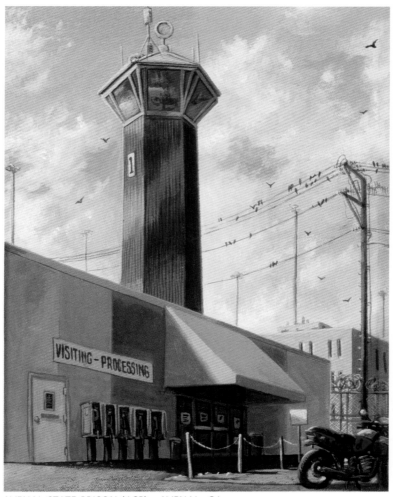

AVENAL STATE PRISON (ASP) - AVENAL, CA

Opened: 1987	640 Acres
Security Levels:	II
Yearly Operating Budget:	$92 million
Total Staff:	1,463
Total Design Capacity:	2,320
Dec. 2000 Inmate Population:	6,466

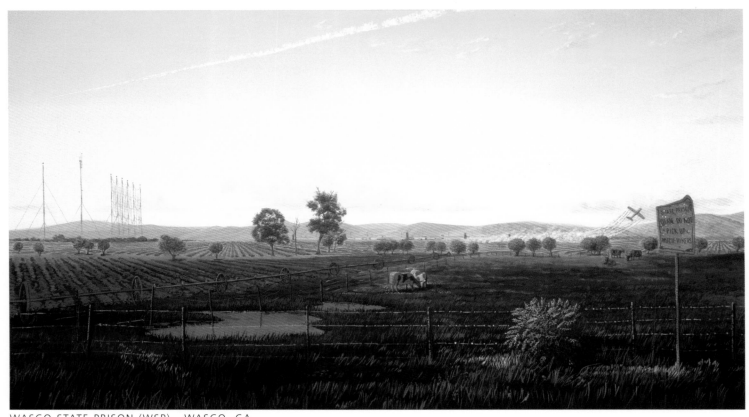

WASCO STATE PRISON (WSP) - WASCO, CA

Opened: 1991	634 Acres
Security Levels:	I, III, and RC
Yearly Operating Budget:	$ 88 million
Total Staff:	1,299
Total Design Capacity:	3,104
Dec. 2000 Inmate Population:	6,034

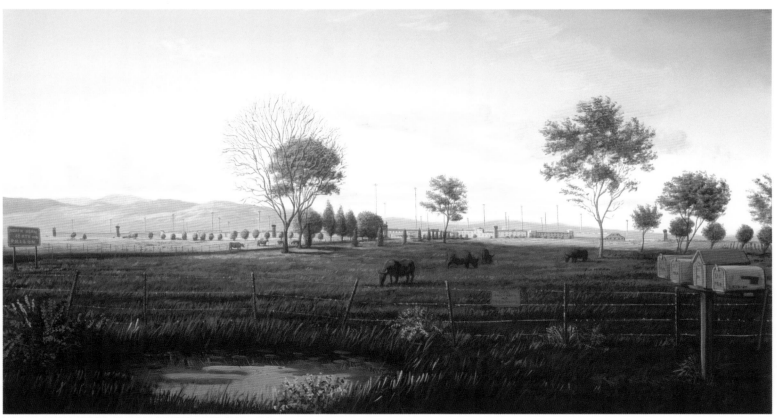

NORTH KERN STATE PRISON (NKSP) - DELANO, CA

Opened: 1993	640 Acres
Security Levels:	I, III, and RC
Yearly Operating Budget:	$ 78 million
Total Staff:	1,185
Total Design Capacity:	2,492
Dec. 2000 Inmate Population:	4,962

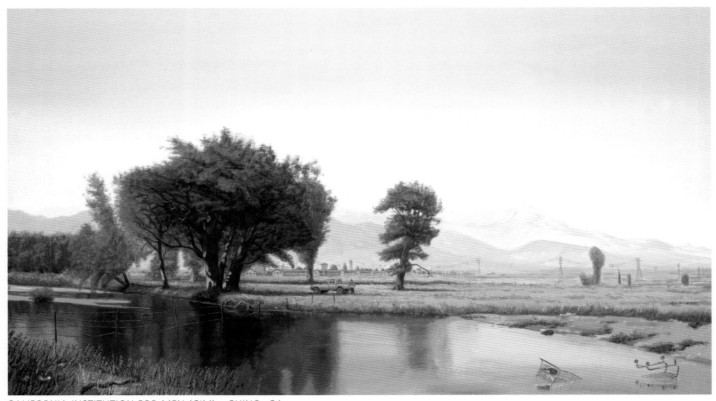

CALIFORNIA INSTITUTION FOR MEN (CIM) - CHINO, CA

Opened: 1941	2,500 Acres
Security Levels:	I and RC
Yearly Operating Budget:	$ 111 million
Total Staff:	1,771
Total Design Capacity:	2,778
Dec. 2000 Inmate Population:	6,298

Note: California's third prison, unique at the time
and known then as "the prison without walls"

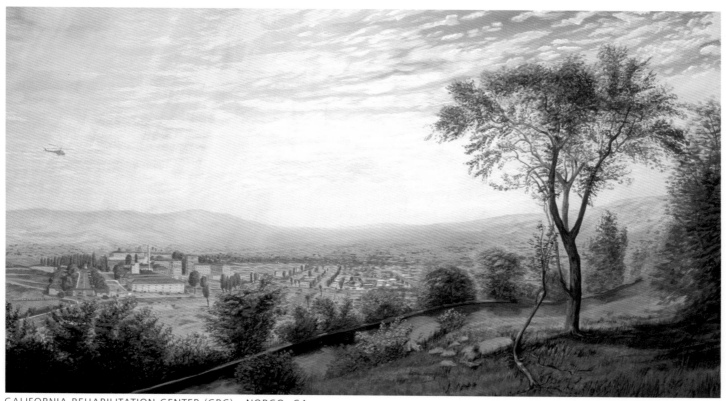

CALIFORNIA REHABILITATION CENTER (CRC) - NORCO, CA

Opened: 1962 93 Acres
Security Levels: II (includes 808 women)
Yearly Operating Budget: $ 78 million
Total Staff: 1,257
Total Design Capacity: 2,314
Dec. 2000 Inmate Population: 4,769

39

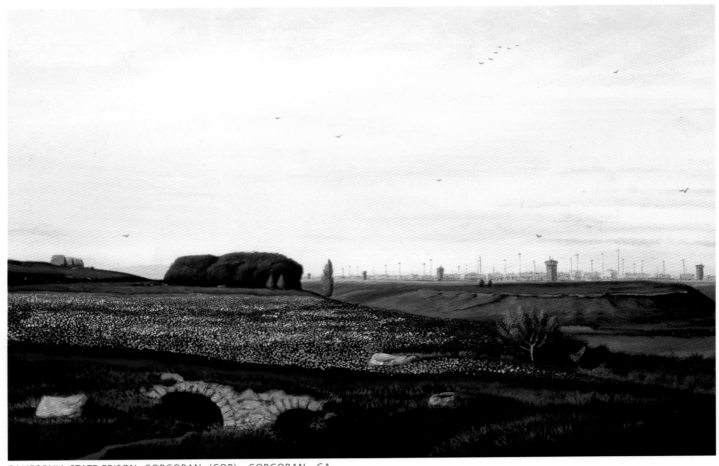

CALIFORNIA STATE PRISON, CORCORAN (COR) - CORCORAN , CA

Opened: 1988	942 Acres
Security Levels:	I, III, IV, SHU and PHU
Yearly Operating Budget:	$ 118 million
Total Staff:	1,723
Total Design Capacity:	2,916
Dec. 2000 Inmate Population:	4,867

VALLEY STATE PRISON FOR WOMEN (VSPW) - CHOWCHILLA, CA

Opened: 1995	640 Acres
Security Levels:	I, II, III, IV, RC and SHU
Yearly Operating Budget:	$63 million
Total Staff:	937
Total Design Capacity:	1,980
Dec. 2000 Inmate Population:	3,570

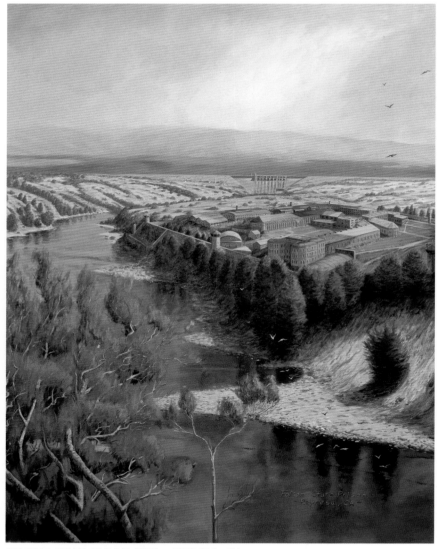

FOLSOM STATE PRISON (FSP) - REPRESA, CA

Opened: 1880	40 Acres
Security Levels:	I, II
Yearly Operating Budget:	$ 62 million
Total Staff:	795
Total Design Capacity:	2,064
Dec. 2000 Inmate Population:	3,880

Note: Built by inmates out of local stone, Folsom is California's second oldest prison and was one of the first maximum security prisons in the Untied States, although it no longer has a SHU unit. All California license plates are made there.

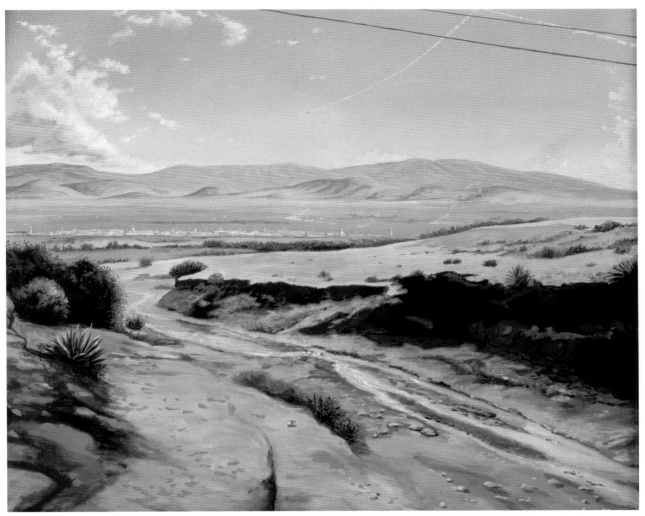

RICHARD J. DONOVAN CORRECTIONAL FACILITY AT ROCK MOUNTAIN (RJD) - SAN DIEGO, CA

Opened: 1987	780 Acres
Security Levels:	I, III, and RC
Yearly Operating Budget:	$ 78 million
Total Staff:	1,053
Total Design Capacity:	2,235
Dec. 2000 Inmate Population:	5,243

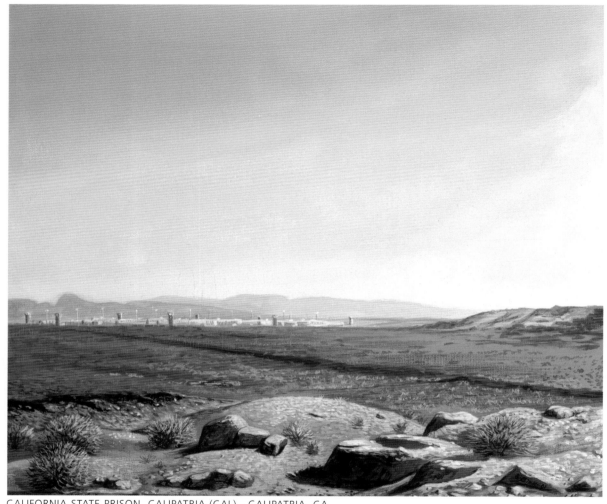

CALIFORNIA STATE PRISON, CALIPATRIA (CAL) - CALIPATRIA, CA

Opened: 1992	1,228 Acres
Security Levels:	I and IV
Yearly Operating Budget:	$ 78 million
Total Staff:	1,143
Total Design Capacity:	2,208
Dec. 2000 Inmate Population:	4,107

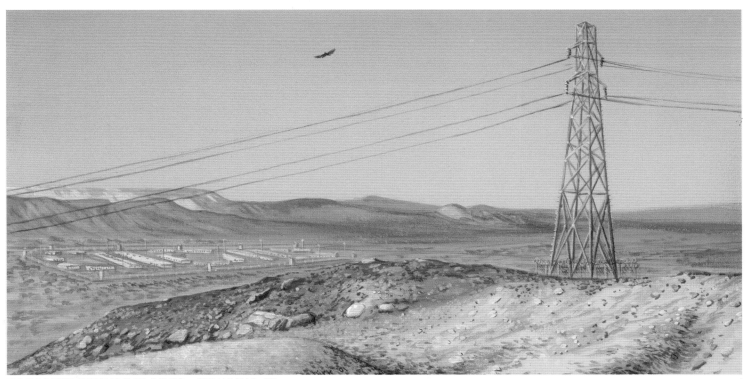

HIGH DESERT STATE PRISON (HDSP) - SUSANVILLE, CA

Opened: 1995	325 Acres
Security Levels:	I, III, IV and RC
Yearly Operating Budget:	$96 million
Total Staff:	1,246
Total Design Capacity:	2,224
Dec. 2000 Inmate Population:	4,293

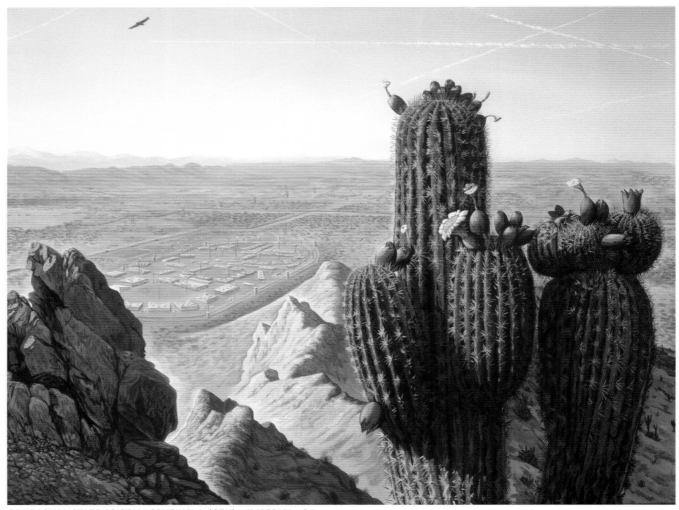

CALIFORNIA STATE PRISON, CENTINELA (CEN) - IMPERIAL, CA

Opened: 1993 2,000 Acres
Security Levels: I, III, and IV
Yearly Operating Budget: $ 81 million
Total Staff: 1,541
Total Design Capacity: 2,208
Dec. 2000 Inmate Population: 4,526

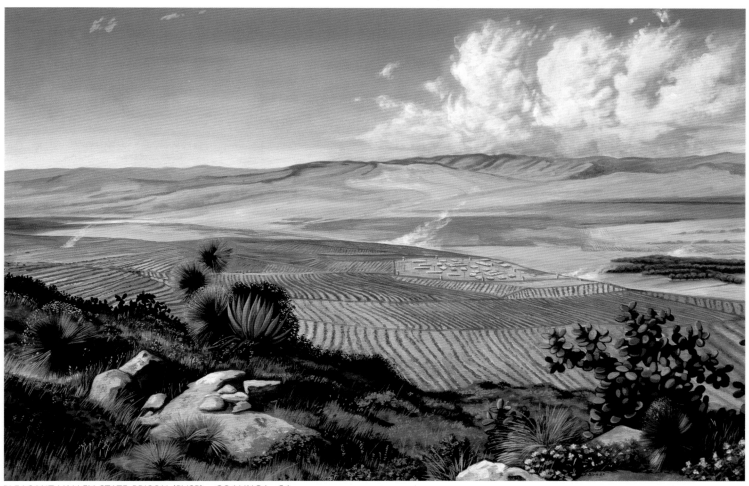

PLEASANT VALLEY STATE PRISON (PVSP) - COALINGA, CA

Opened: 1994	640 Acres
Security Levels:	I and III
Yearly Operating Budget:	$ 88 million
Total Staff:	1,080
Total Design Capacity:	2,208
Dec. 2000 Inmate Population:	4,889

MULE CREEK STATE PRISON (MCSP) - IONE, CA

Opened: 1987 866 Acres
Security Levels: I, III, and IV
Yearly Operating Budget: $ 73 million
Total Staff: 906
Total Design Capacity: 1,700
Dec. 2000 Inmate Population: 3,501

48

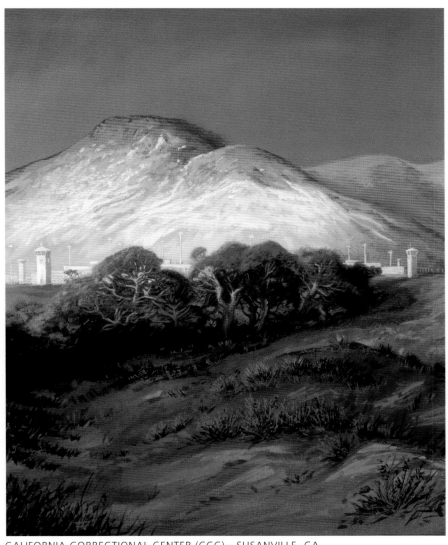

CALIFORNIA CORRECTIONAL CENTER (CCC) - SUSANVILLE, CA

Opened: 1963 1,100 Acres
Security Levels: I, II, III, and Camp
Yearly Operating Budget: $ 81 million
Total Staff: 1,135
Total Design Capacity: 3,682
Dec. 2000 Inmate Population: 5,818

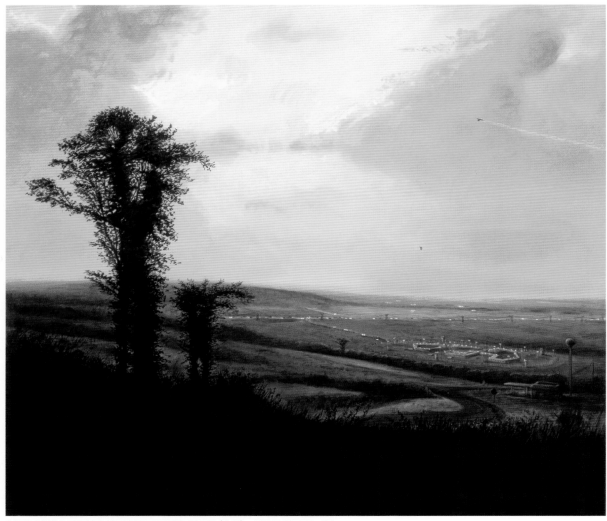

CALIFORNIA CORRECTIONAL INSTITUTION (CCI) - TEHACHAPI, CA

Opened: 1933 Reopened: 1954	1,650 Acres
Security Levels:	I, II, III, IV and SHU
Yearly Operating Budget:	$ 107 million
Total Staff:	1,678
Total Design Capacity:	2,808
Dec. 2000 Inmate Population:	5,496

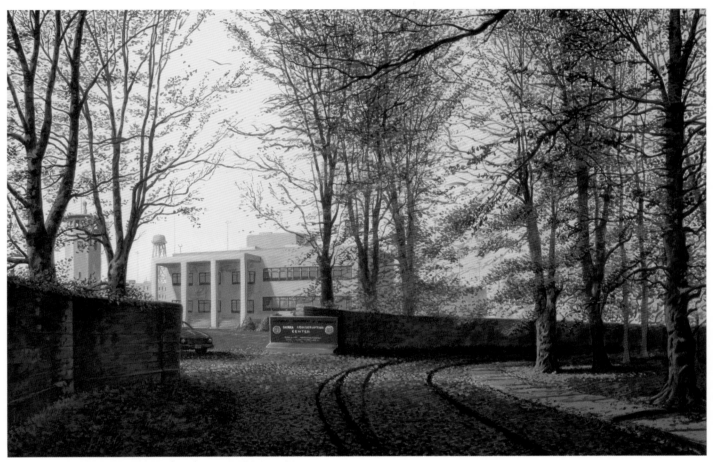

SIERRA CONSERVATION CENTER (SCC) - JAMESTOWN, CA

Opened: 1965	420 Acres
Security Levels:	I, II, III, and Camp (inc. women)
Yearly Operating Budget:	$497 million
Total Staff:	1,110
Total Design Capacity:	3,926
Dec. 2000 Inmate Population:	6,240

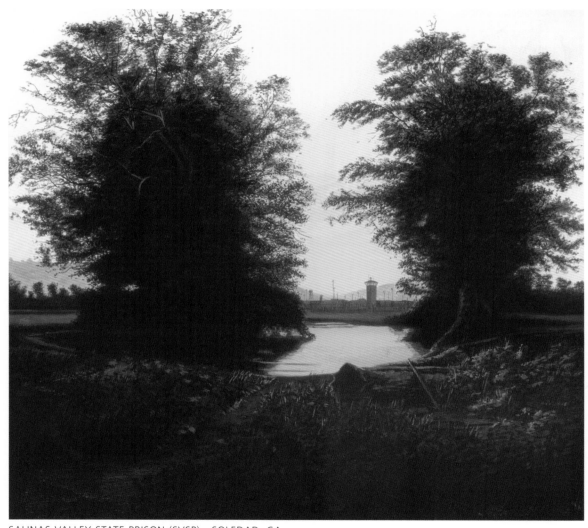

SALINAS VALLEY STATE PRISON (SVSP) - SOLEDAD, CA

Opened: 1996	300 Acres
Security Levels:	I, II, III, and IV
Yearly Operating Budget:	$ 93 million
Total Staff:	1,120
Total Design Capacity:	2,224
Dec. 2000 Inmate Population:	4,093

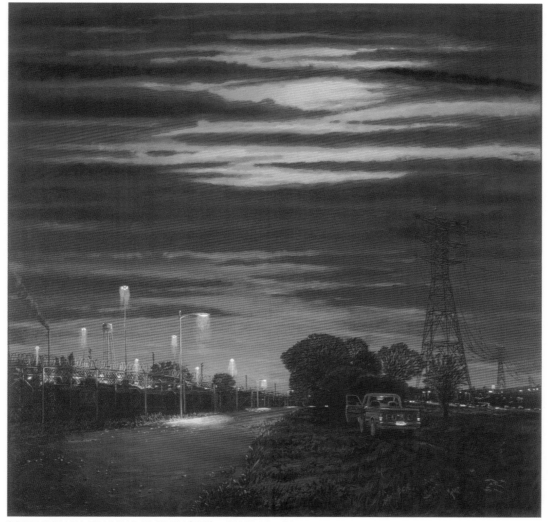

CORRECTIONAL TRAINING FACILITY (CTF) - SOLEDAD, CA

Opened: 1946	680 Acres
Security Levels:	I, II
Yearly Operating Budget:	$ 104 million
Total Staff:	1,445
Total Design Capacity:	2,981
Dec. 2000 Inmate Population:	7,133

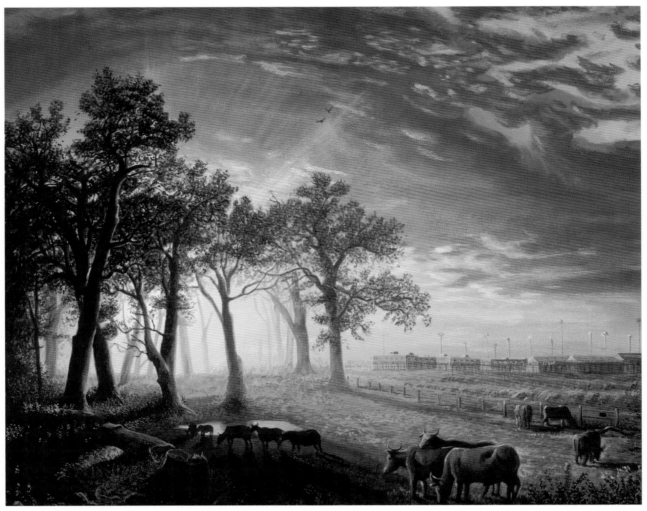

NORTHERN CALIFORNIA WOMEN'S FACILITY (NCWF) - STOCKTON, CA

Opened: 1987	134 Acres
Security Levels:	II, III, and RC
Yearly Operating Budget:	$ 20 million
Total Staff:	296
Total Design Capacity:	400
Dec. 2000 Inmate Population:	759

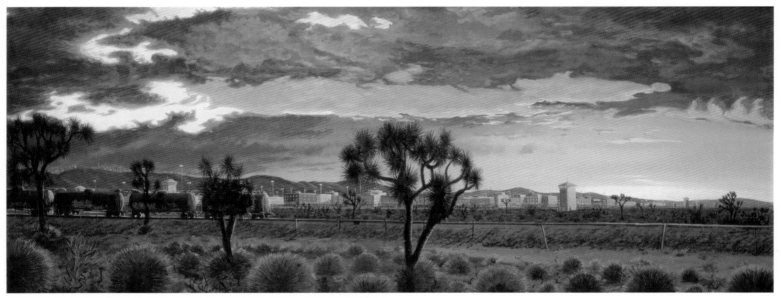

CALIFORNIA STATE PRISON, LOS ANGELES COUNTY (LAC) - LANCASTER, CA

Opened: 1993 262 Acres
Security Levels: I and IV
Yearly Operating Budget: $ 92 million
Total Staff: 1,251
Total Design Capacity: 1,200
Dec. 2000 Inmate Population: 4,185

55

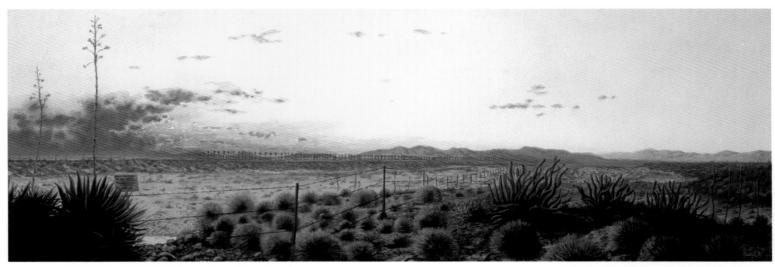

CHUCKAWALLA VALLEY STATE PRISON (CVSP) - BLYTHE, CA

IRONWOOD STATE PRISON (ISP) - BLYTHE, CA

Opened: 1988	1,735 Acres	
Security Levels:	I and II	
Yearly Operating Budget:	$ 60 million	
Total Staff:	898	
Total Design Capacity:	1,738	
Dec. 2000 Inmate Population:	3,700	

Opened: 1994	1,700 Acres
Security Levels:	I and III
Yearly Operating Budget:	$ 83 million
Total Staff:	1,096
Total Design Capacity:	2,200
Dec. 2000 Inmate Population:	4,579

Sandow Birk received his BFA from Otis Art Institute of Parson's School of Design, Los Angeles, in 1988. In 1985 he studied at the Bath Academy of Art, Bath, England, and at the American College in Paris/Parson's School of Design in Paris, France. He is the recipient of numerous awards including a J. Paul Getty Fellowship for the Visual Arts; a Fulbright Grant to travel to Rio de Janeiro; a Guggenheim Fellowship; and a National Endowment for the Arts US/Mexico International Exchange Scholarship. His work has been included in 25 group exhibitions and he has had over 20 solo exhibitions at such institutions as the Laguna Art Museum, Laguna Beach, CA; San Jose Museum of Art, San Jose, CA; and the Centro Nacional de las Artes, Mexico City, DF. Birk has been interviewed on NPR for his "In Smog and Thunder: Historical Works from the Great War of the California" project and has received regional and national reviews of his exhibitions in the *Los Angeles Times*, *Juxtapoz Magazine*, *The New York Times*, *Art Issues*, the *Chicago Sun-Times* to name only some. Birk resides in Long Beach, CA.

TERMINAL ISLAND FEDERAL CORRECTIONAL INSTITUTION, SAN PEDRO, CA, 2000

EXHIBITION CHECKLIST

INCARCERATED: VISIONS OF CALIFORNIA IN THE 21ST CENTURY
Paintings and Prints from the PRISONATION Series by Sandow Birk

July 7 - August 19, 2001
Santa Barbara Contemporary Arts Forum

PAINTINGS

All measurements are in inches and of framed dimensions; height precedes width; all paintings are oil and acrylic on canvas unless noted otherwise.

1. *Avenal State Prison - Avenal, CA, 2001*
 18" x16"
 Courtesy Catharine Clark Gallery, San Francisco

2. *California Correctional Center - Susanville, CA, 2001*
 33 1/2" x 29 1/2"
 Collection Marcia Tanner and Winsor Soule, Berkeley, CA

3. *California Correctional Institution - Tehachapi, CA, 2000*
 34" x 37"
 Collection Mark Andrus, San Juan Capistrano, CA

4. *California Institution for Men - Chino, CA, 2000*
 24"x 42"
 Courtesy Koplin Gallery, Los Angeles

5. *California Institution for Women - Frontera, CA, 2000*
 26" x 32"
 Courtesy Koplin Gallery, Los Angeles

6. *California Medical Facility - Vacaville, CA, 2000*
 17" x 15"
 Collection Kay and Jon Gosse, Issaquah, WA

7. *California Men's Colony - San Luis Obispo, CA, 2001*
 24" X 28"
 Collection Mark Andrus, San Juan Capistrano, CA

8. *California Rehabilitation Center, Norco, CA, 2000*
 24" x 42"
 Courtesy Koplin Gallery, Los Angeles

9. *California State Prison, Corcoran - Corcoran, CA, 2001*
 20" x 27"
 Courtesy of Catharine Clark Gallery, San Francisco

10. *California State Prison Sacramento (New Folsom) - Represa, CA, 2001*
 21" x 24"
 Collection Kay and Jon Gosse, Issaquah, WA

11. *California State Prison, Solano - Vacaville, CA, 2001*
 31" x 33"
 Courtesy of Catharine Clark Gallery, San Francisco

12. *California State Prison, Calipatria - Calipatria, CA, 2001*
 16" x 17 3/4"
 Courtesy Catharine Clark Gallery, San Francisco

13. *California State Prison Los Angeles County - Lancaster, CA, 2001*
 24" x 49"
 Collection Nick Debs, New York

14. *California State Prison, Centinela - Imperial, CA, 2001*
 35" x 43"
 Courtesy Catharine Clark Gallery, San Francisco

15. *California Substance Abuse Treatment Facility and State Prison - Corcoran, CA, 2001*
17" x 15"
Collection Kevin King, San Francisco

16. *Central California Women's Facility - Chowchilla, CA, 2001*
31" x 43 1/2"
Collection Kevin Osinski and Marc Sinykin, Emerald Hills, CA

17. *Ironwood State Prison and Chuckawalla Valley State Prison - Blythe, CA, 2001*
27" x 62"
Courtesy of Catharine Clark Gallery, San Francsico

18. *Correctional Training Facility - Soledad, CA, 2000*
37" x 73"
Collection of Angela and Gerry Harrington, Los Angeles

19. *Deuel Vocational Institution - Tracy, CA, 2001*
15" x 18"
Courtesy Catharine Clark Gallery, San Francisco

20. *Folsom State Prison - Represa, CA, 2000*
54" x 43"
Courtesy Koplin Gallery, Los Angeles

21. *High Desert State Prison - Susanville, CA, 2001*
13" x 20"
Courtesy Catharine Clark Gallery, San Francisco

22. *Mule Creek State Prison - Ione, CA, 2001*
18" x 27"
Courtesy Catharine Clark Gallery, San Francisco

23. *North Kern State Prison - Delano, CA, 2000*
24" x 42"
Courtesy Koplin Gallery, Los Angeles

24. *Northern California Womens' Facility - Stockton, CA, 2001*
25" x 29"
Courtesy of Catharine Clark Gallery, San Francisco

25. *Pelican Bay State Prison - Crescent City, CA, 2001*
37" x 41"
Courtesy of Catharine Clark Gallery, San Francisco

26. *Pleasant Valley State Prison - Coalinga, CA, 2000*
24" x 36"
Courtesy Koplin Gallery, Los Angeles

27. *Richard J. Donovan Correctional Facility at Rock Mountain - San Diego, CA, 2000*
27" x 30"
Courtesy Koplin Gallery, Los Angeles

28. *Salinas Valley State Prison - Soledad CA, 2001*
28" x 30"
Courtesy of Catharine Clark Gallery, San Francisco

29. *San Quentin State Prison - San Quentin, CA, 2000*
66" x 90" (unframed)
Collection Mr. and Mrs. Edward Byron Smith, Jr., Long Grove, IL

30. *Visiting Day at San Quentin State Prison, 2000*
26" x 22"
Collection of Angela and Gerry Harrington, Los Angeles

31. *Sierra Conservation Center - Jamestown, CA, 2001*
 31" x 44"
 Courtesy Catharine Clark Gallery, San Francisco

32. *Valley State Prison For Women - Chowchilla, CA, 2001*
 14" x 22"
 Courtesy Catharine Clark Gallery, San Francisco

33. *Wasco State Prison - Wasco, CA, 2000*
 24" x 42"
 Courtesy Koplin Gallery, Los Angeles

34. *Terminal Island Federal Correctional Institution - San Pedro,*
 CA, 2000
 43" x 54" (unframed)
 Collection Angela and Gerry Harrington, Los Angeles

35. *Atascadero State Hospital for the Criminally Insane,*
 Atascadero, CA, 2000
 20" x 14"
 Collection Greg and Marcella Phillips, Pacific Palisades, CA

OLD FOLSOM STATE PRISON - REPRESA, CA, 2000

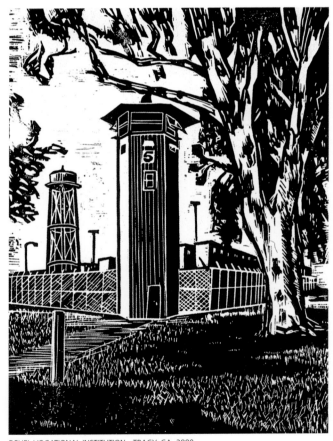

DEUEL VOCATIONAL INSTITUTION - TRACY, CA, 2000

PRINTS

All measurements are in inches and of image size; height precedes width; all prints are linoleum block print, and Courtesy Koplin Gallery, Los Angeles, unless noted otherwise.

1. *Salinas Valley State Prison - Soledad, CA, 2000*
 Edition 10, 5" x 7"

2. *California State Prison, Solano-Vacaville, CA, 2000*
 Edition 10, 5" x 7"

3. *Terminal Island Federal Correctional Institution -*
 San Pedro, CA, 2000
 Edition 10, 5" x 7

4. *Pleasant Valley State Prison - Coalinga, CA, 2000*
 Edition 10, 5" x 7"

5. *High Desert State Prison - Standish, CA, 2000*
 Edition 10, 5" x 7"

6. *Guard Tower #2, Norco, CA, 2000*
 Edition 15, 7" x 5"

7. *Deuel Vocational Institution - Tracy, CA, 2000*
 Edition 10, 7" x 5"

8. *California State Prison - Corcoran, CA, 2000*
 Edition 10, 5" x 7"

9. *Old Folsom State Prison - Represa, CA, 2000*
 Etching, Edition 20, 12" x 9"

10. *California Men's Colony - San Luis Obispo, CA, 2001*
 Edition 25, 9" x 6"
 Published for the Santa Barbara Contemporary Arts Forum

American Idyll - San Quentin, CA, 2001
medium: Lithographic Monoprint with hand coloring
edition size: edition varée of 6
edition number: E.V. 6/6
size: print 22" x 30", image 15" x 22"

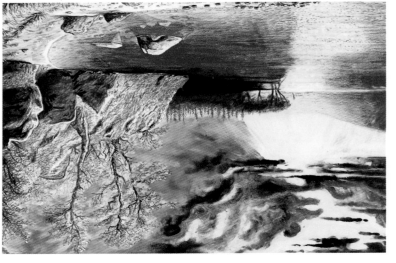

These prints were created by Sandow Birk at Trillium Press, an experimental, collaborative press in Brisbane, California. Each print consists of many layers, including lithography, monoprinting, and hand drawing. Using techniques developed by Trillium founder David Salgado, Sandow created over 45 original prints. These prints are available through Catharine Clark Gallery and Trillium Press. To see more of Sandow's prints, please visit.

www.trilliumpress.com

Storm Over San Quentin, CA, 2001
medium: Lithographic Monoprint with hand coloring
edition size: edition varée of 6
edition number: E.V. 1/6
size: print 22" x 30", image 15" x 22"

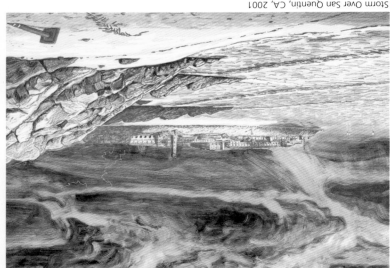

American Landscape, San Quentin, CA, 2001
medium: Lithographic Monoprint with hand coloring
edition size: edition varée of 2
edition number: E.V. 2/2
size: print 22" x 30", image 15" x 22"

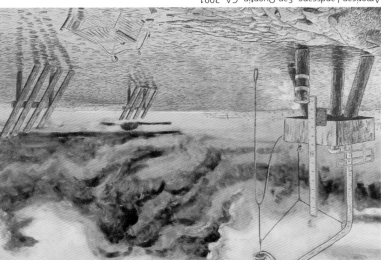